AN
ALPHABET
OF
LONDON

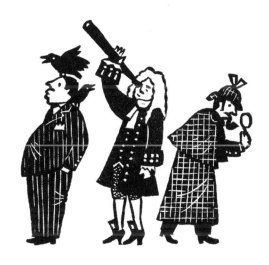

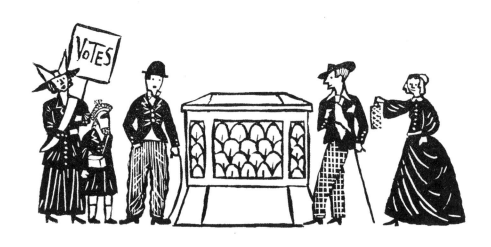

AN
ALPHABET
OF
LONDON

Christopher Brown

MERRELL
LONDON · NEW YORK

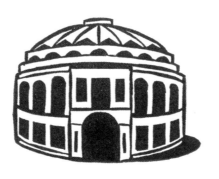

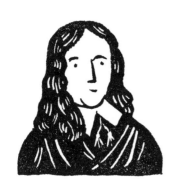

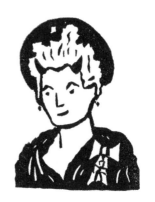

FOREWORD

Reading Christopher Brown's wonderful evocation of his childhood in London took me whizzing back to my own, also spent in London. I grew up on the other side of town, a teeny bit later, in Alan Bennett's NW1, which was then peopled with tramps (to whom we took out tea and sandwiches), drunks (whom we crossed the road to avoid), nuns (ditto) and middle-class intellectuals (who were rather pleased with themselves). Shopping was done in Camden High Street, where there were butchers and bakers and fishmongers, and a delicatessen (in those days, these were as rare outside Soho as hens' teeth), where a rather stern German lady would slip me slices of Bratwurst behind my grandmother's back.

Added to that was a wealth of colourful characters: chimney sweeps covered in soot, window cleaners covered in ladders and charladies covered in buckets. The milkman would turn up on Saturday bearing not only milk but also bottled orange juice, blissful nectar to us children, who were in those days allowed to play together outside.

This was the 1960s, and London still bore the scars of the Second World War, with enormous boards surrounding giant bomb craters and ominous gaps in terraces of houses. It may have been swinging but it was still distinctly shabby and grimy. Now, of course, London is newly polished and outfitted in white paint, gilding and skyscrapers, a truly prosperous, international city, one that has an abundance of historical interest, secret places, extraordinary buildings and towering monuments like no other, all there to be explored and experienced.

What I would love to do is take a holiday with this charming book in hand, visit all the places Christopher has drawn, and experience his choice of the known, the delightful, the quirky and the eccentric. Who knows, someday I might just do that very thing, but for now, why don't you?

Jasper Conran

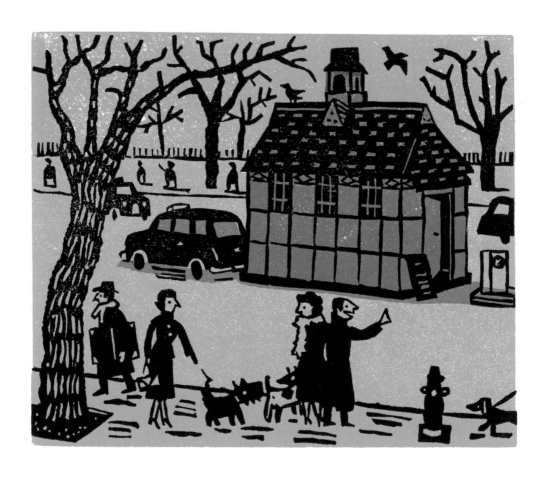

Cabman's Hut (Mr Bawden in London)

LIVING IN LONDON

It's unusual for someone who lives and works in London to have been born here, but I was. Apart from some extended holidays, my entire life has been spent living in the city. Since my childhood I have been in awe of it: the architecture, the River Thames, all that history, and the people who flow in and out like the tide. London has changed greatly since 1953, when I was born, and although that has mostly been for the better I can't help feeling nostalgic about the city of my youth.

London in the 1950s appeared almost monochromatic. The pastel paintwork favoured by young couples of the Habitat generation hadn't yet enlivened its terraced streets. Street doors were maroon, forest green or black. Navy sun blinds with carved wooden acorns attached to a cord shut out light and prying eyes from front rooms, and lace curtains hung heavy, waiting to be pulled back ever so slightly to keep an eye on comings and goings in the street.

My childhood was spent in Putney, one of the many small towns that make up the city. There was no real need to leave: there were four cinemas, including the ABC, where I went on Saturday mornings. My sister, who is considerably older than me, had in her time gone to the Hippodrome, to which (my Auntie Kathleen insisted) a better class of children went. The High Street, which had not yet been invaded by chain stores or fast-food restaurants, had 'decent' shops, such as Cuffs, with its 'flying fox' payment system that whizzed cash and receipts around the shop on overhead wires. My mother would place her orders at the local shops on the Lower Richmond Road: Hawkins the grocer, Buckley the butcher and Hedges the greengrocer. Later in the day the supplies would be delivered by lanky teenagers on bicycles. There was a hospital, schools, parks and playgrounds, but – most excitingly – Putney also had the River Thames, which, with the High Street, the Upper Richmond Road and Putney Common, formed the border of my territory.

Yet I did cross that border, to go to the public swimming pools in Fulham, Wandsworth, Battersea, Roehampton or Richmond, or shopping 'up west' to Oxford Street, Kensington High Street or Knightsbridge. It was at Harrods that I had my first haircut, at the age of two and a half, and I remember sitting on a rocking horse before my shearing. Harrods also

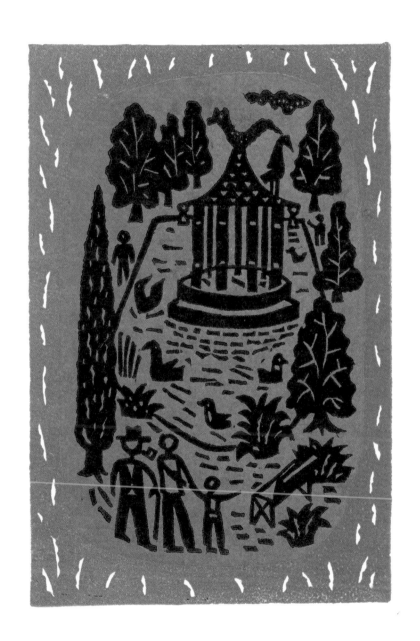

Osterley Park

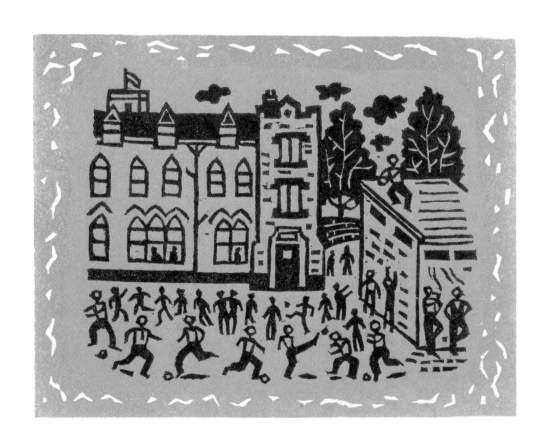

Break-time

had a pet department that was more akin to a small zoo; I haven't been there for many years, but I can't imagine that it still has the same exotic animals.

My mother and I went by bus on these shopping expeditions, and it was with her that I would visit her sister, my Auntie Becky, in Battersea. This meant a visit to the Festival Gardens with its Guinness Clock, fountains, treetop walk and Cave of the Four Winds. As we walked into the park the grey of the streets gave way to the technicolour of the funfair.

It was also with my mother that I first was pushed, then walked to and from kindergarten across Putney Common,

over a railway footbridge, where we would usually stop and wait to be enveloped in a cloud of pale steam from a passing locomotive. On those days when London was covered in a blanket of yellow–grey fog and sounds were muffled, I would hold tightly on to her hand.

My parents (left) were born in London: my mother in Wandsworth and my father in Sidcup. My father's parents lived in the

same street as us, having moved there before the First World War. In fact, because my grandmother had a habit of buying houses, most of my father's sisters and brothers had lived or still lived close to the old couple. My grandfather (below) had done the Knowledge, and I still have his green enamel cabman's badge, number 7271. There is also a photograph of him in 1915 with his cab, cabmen and family. Also in the photograph is a small boy: my father.

My grandparents were Victorians, both born in the mid-1870s. Although I loved my grandmother, she was rather formidable, and it was my grandfather whom I adored. I did,

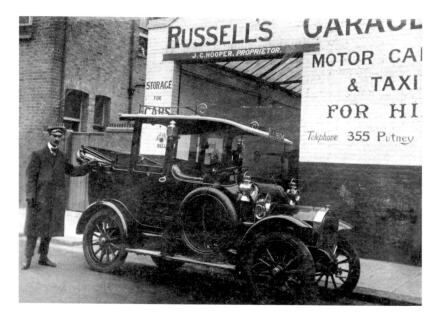

Corner Shop

Highgate

however, enjoy our occasional trips to Portobello Road or Petticoat Lane markets, since my grandmother had a great eye for a bargain. On Petticoat Lane there was a particular Jewish bakery from which she liked to buy cakes; she didn't share them but instead had them boxed up and took them home, to be eaten at her leisure, helping her to maintain her ample figure. After her death, when I was seven, my grandfather left their house, with its heavily ornate Victorian furniture and darkly patterned embossed wallpaper, and moved to my Auntie Kathleen's a few yards away.

Those trips to Petticoat Lane usually meant a treat for me. On one occasion this was a stuffed alligator, and sitting astride it in the garden with my other toys I would pretend I was in the jungle. One day it mysteriously disappeared; I think my mother might have been responsible for its reintroduction into the wild.

Sundays in London were blissfully quiet, the silence broken only by church bells calling the faithful to worship. While my mother prepared the Sunday roast in a steam-filled kitchen, I would spend a few hours with my grandfather and my father. On sunny summer or autumn days we would usually go to see the deer in Richmond Park, the windmill on Wimbledon Common, or a big house – Chiswick, Ham, Osterley or Syon. If we drove west we would pass the great

art deco factories of Gillette and Firestone Tyres at Brentford, which with their sleek lines looked like giant stranded ocean liners. The car would soon fill with my grandfather's aromatic pipe-smoke, and when we arrived he would find a bench where he would puff and chew on his pipe or take a pinch of snuff while my father and I walked.

Then there were the days when they took me round London, probably as much for their pleasure as for mine, since both had been cabbies and had a wealth of knowledge of London's streets and their history. Sometimes we would drive in my grandfather's car, a gleaming black Ford Prefect with running boards, or one of the newer, smarter cars my father had at various times: a Ford Zephyr or Zodiac, a Morris Oxford or an Austin Cambridge. They would often break into song, usually old favourites by Florrie Forde, Marie Lloyd and Gus Elen, affecting strong cockney accents with dropped aitches: 'Wiv a ladder and some glasses,/ You could see to 'Ackney Marshes,/ If it wasn't for the 'ouses in between.'

There were fewer traffic restrictions in those days, so we could park and inspect various buildings. The Jewel Tower at Westminster was at that time surrounded by a moat where large green–grey trout swam lazily, breaking the surface only for the morsels we threw to them. Then we would drive on to the City, its streets empty of the weekday bowler-hatted

The Jewel Tower

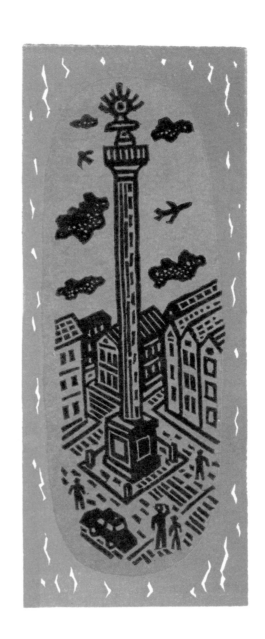

Monument

businessmen with neatly rolled umbrellas and crisp copies of *The Times* tucked under their arms. 'Do you know what this building is?', I was once asked, but before I had a chance to say 'no', the answer came: 'The Old Lady of Threadneedle Street' – the Bank of England. We would then return via the Tower, crossing the bridge and turning round to cross it again, in the vain hope that we might be delayed by its opening for a ship to pass under. We might stop next at the Monument, rising 202 feet, its gilded flames glistening against the blue sky.

'Where did the fire start?', one would test the other.

'Pudding Lane.'

'And where did it end?'

Quickly would come the reply: 'Pye Corner.'

Homewards then to Putney, where my father and grandfather would stop for a pint at the Duke's Head and we would watch the rowing crews passing as the Thames flowed slowly by.

The other important member of my family was my big sister, Janet, who at one point went out with a guardsman. Like Christopher Robin and Alice we went down to Buckingham Palace, hoping to catch sight of him in his scarlet coat and bearskin.

When I wasn't with the men of my family, or my mother or sister, I played either alone or with my cousin and the

other kids who lived close by, pushing a soapbox car along the pavement, stopping to watch the newly resurfaced road being flattened by a steamroller, and peering into the bubbling cauldron of tar with its wonderful smell that wafted along the street. There were few cars, so the streets were almost empty; it was not just the pavements we children had for our playground. Approaching cars could be heard easily, as could the clip-clop of the rag-and-bone man's horse, the clang of his handbell and his cry of 'any old iron'. We would go down to the river to feed the elegant but aggressive swans, cross the bridge over Beverley Brook and watch from the towpath as tugs pulled barges up the river, past Fulham football ground towards Hammersmith. Then we would slide down to the pebbly foreshore to search for pieces of Victorian pottery or clay pipes. In the autumn I would go to Putney Common to collect conkers, kicking, scrabbling and rustling through the leaves to find the largest, shiniest specimens. Today conkers lie unloved by a generation that seems not to know the pleasure of the game.

In the summer there were special days out: to London Zoo, where I would ride, gently swaying, on an elephant or a Bactrian camel, clamber up the Mappin Terraces, and watch the chimps having their tea party as I munched on pungent egg-and-cress sandwiches, laughing at their antics;

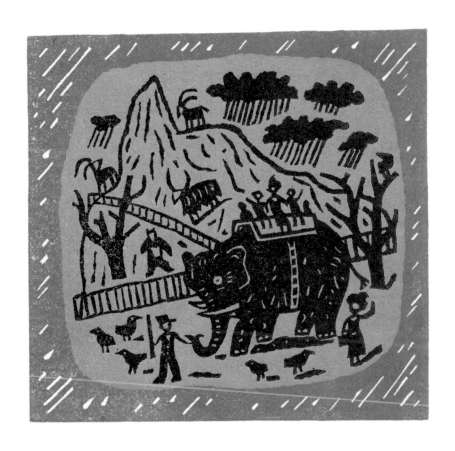

Elephant Ride

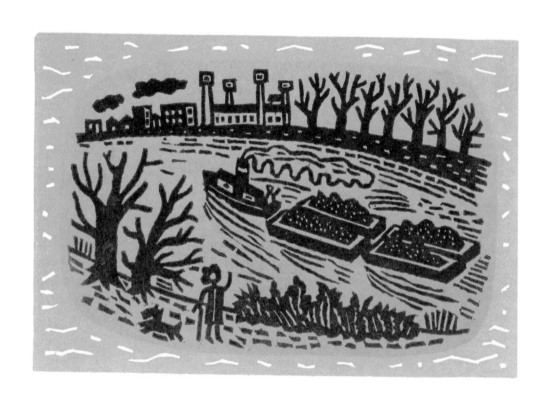

Thames Towpath

or to the Natural History Museum, where I would be greeted by the brontosaurus before exploring the dimly lit galleries with sketchpad and stool, marvelling at the blue whale suspended from the ceiling, the cases of iridescent birds and the rather dusty stuffed lions. Whereas the Natural History Museum seemed reverentially quiet, a short walk up Exhibition Road was the mayhem of the Science Museum, with buttons to press and handles to turn and the 'magic' of automatic doors.

In 2002 I recalled some of these days in a series of prints called 'Cuts from Memory', some of which are shown on pages 8–24. Although home for me was a corner of south-west London, the whole city was there to be explored: the best playground a child could hope for. In my rediscovery and exploration for *An Alphabet of London*, I find it no less impressive or fascinating.

London
September 2011

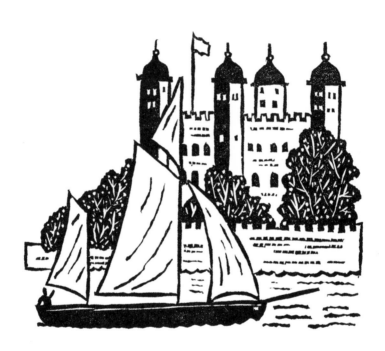

AN
ALPHABET
OF
LONDON

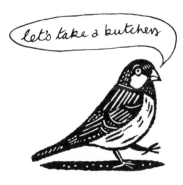

let's take a butchers

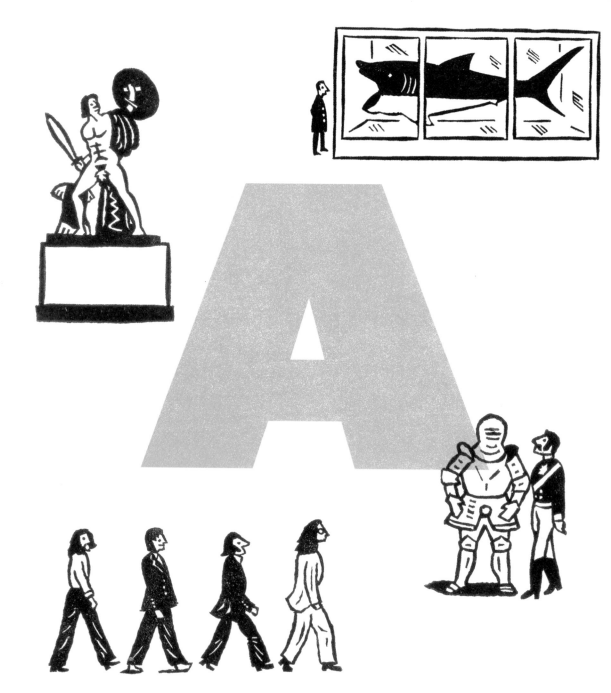

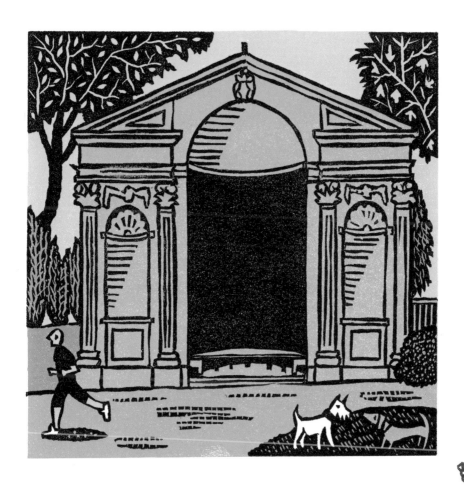

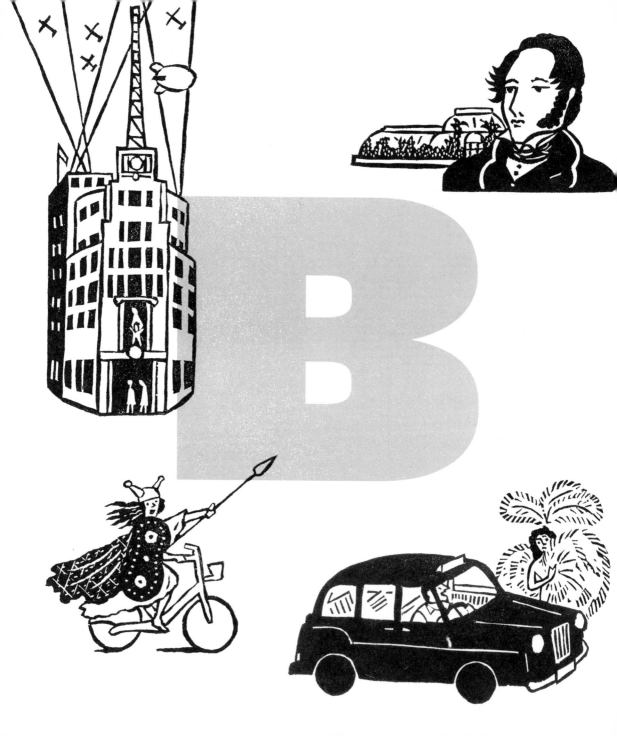

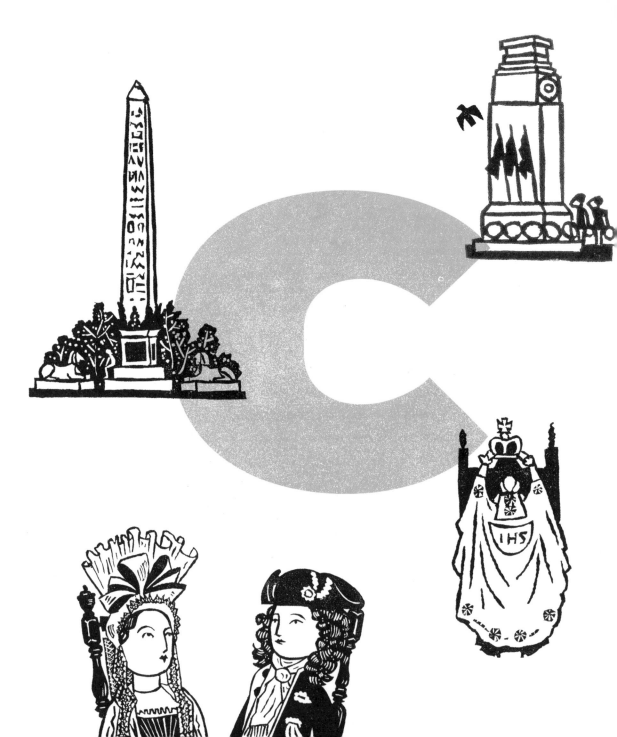

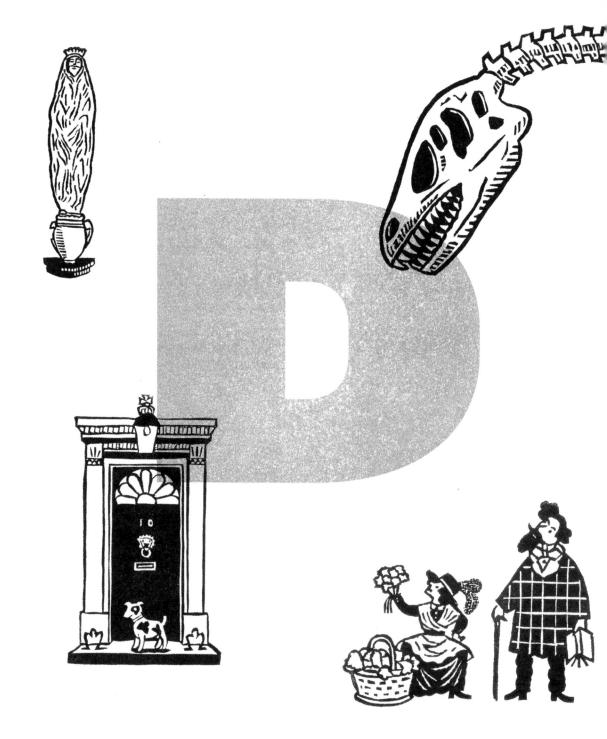

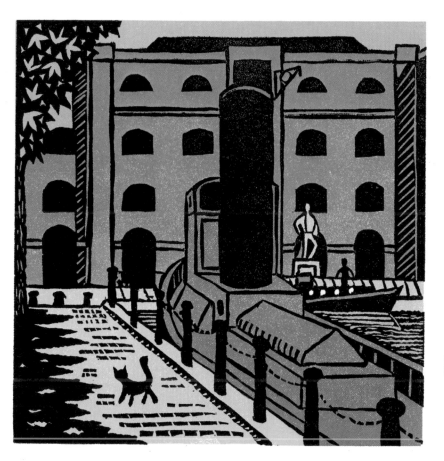

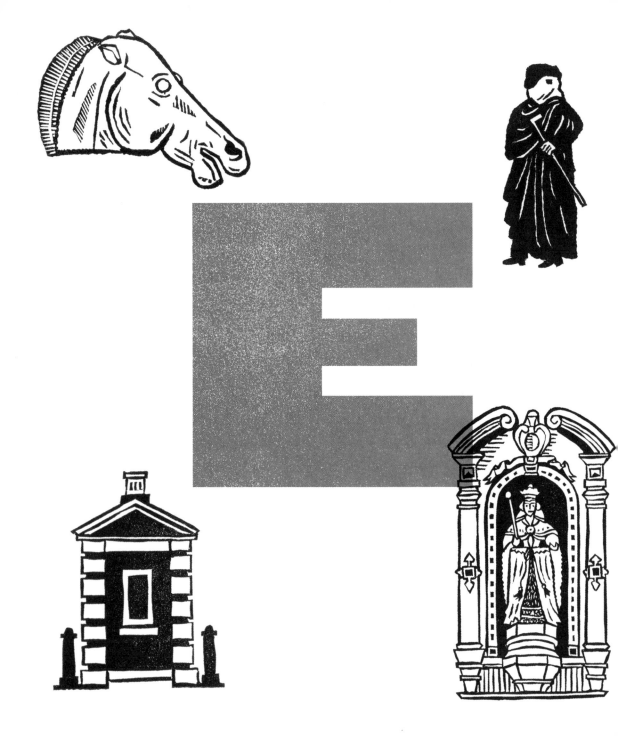

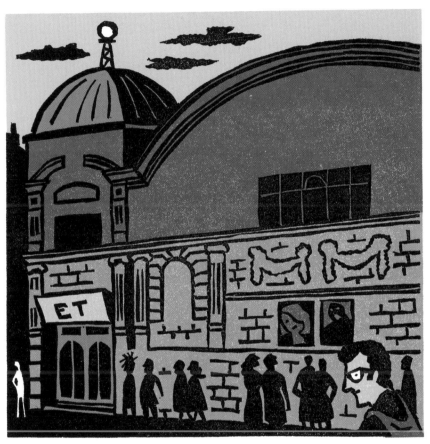

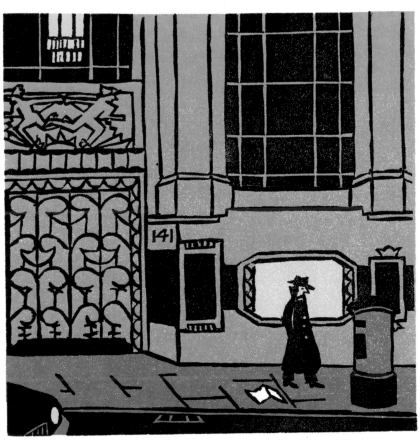

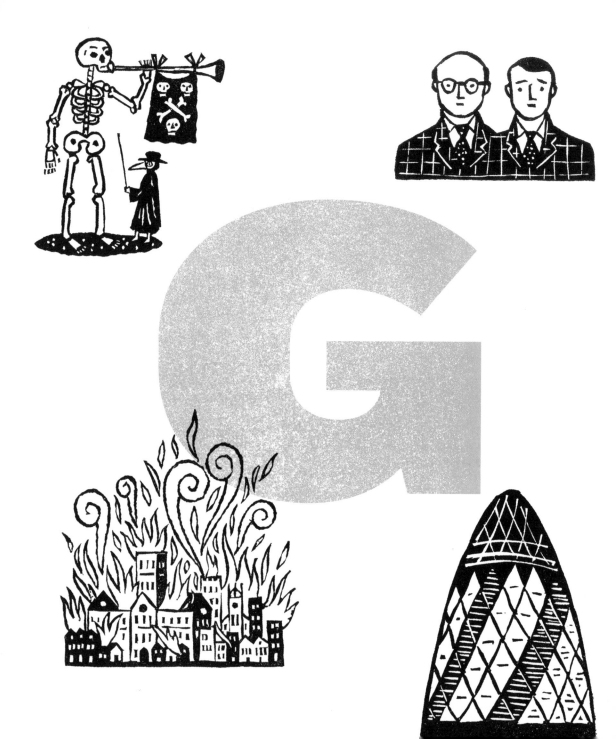

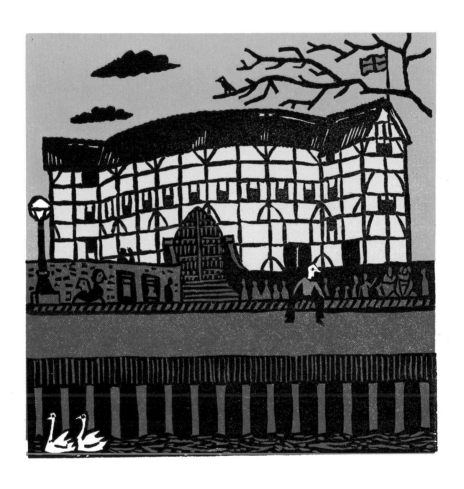

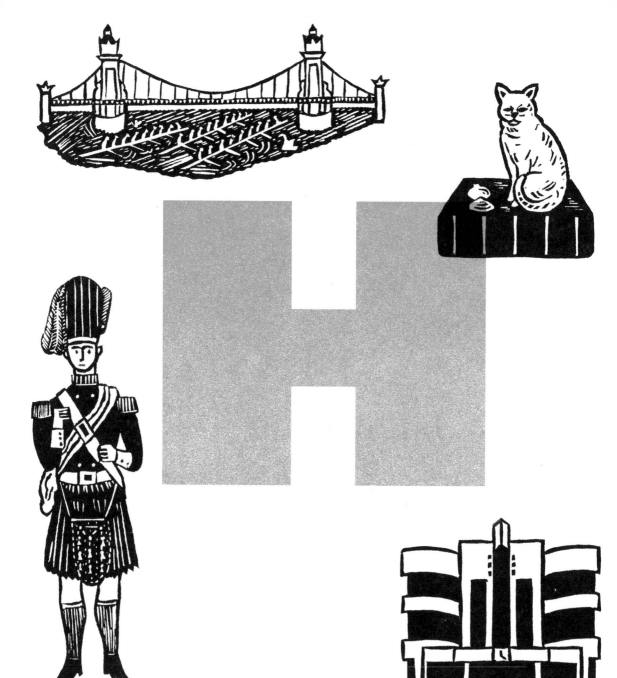

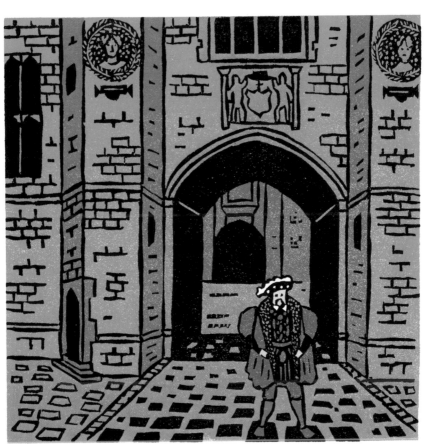

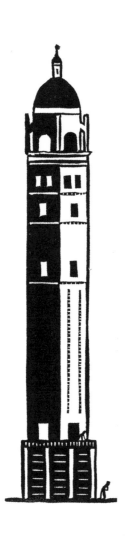

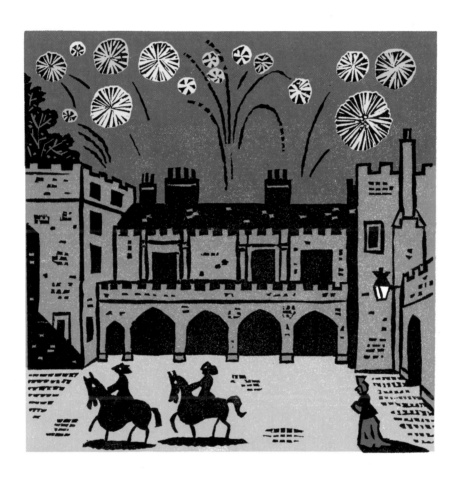

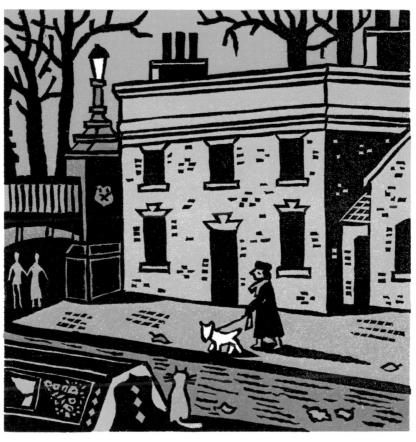

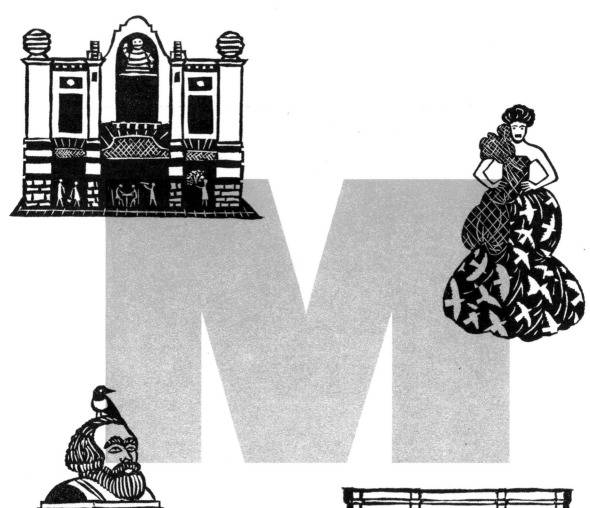

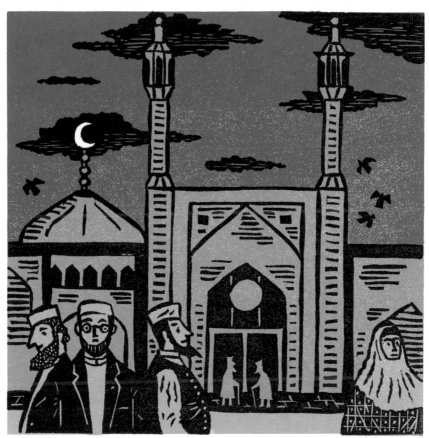

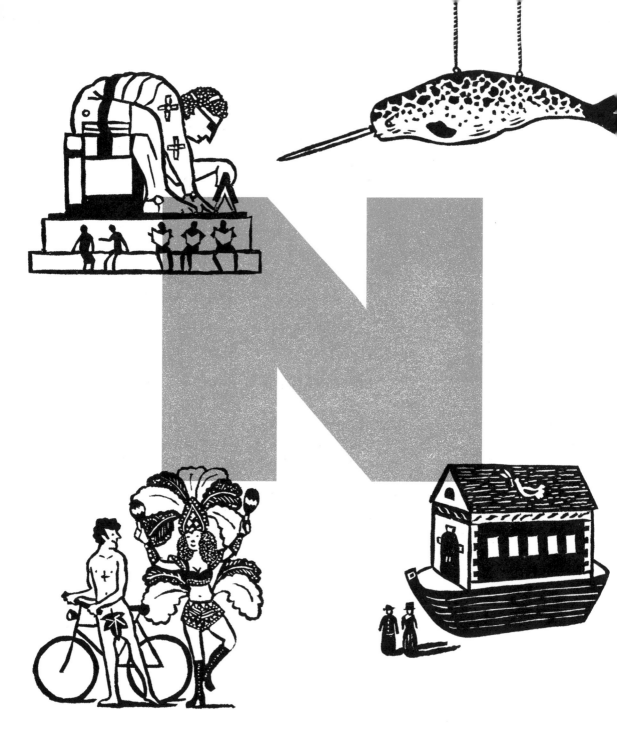

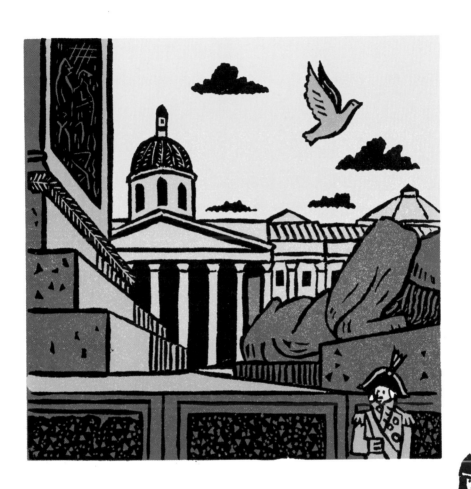

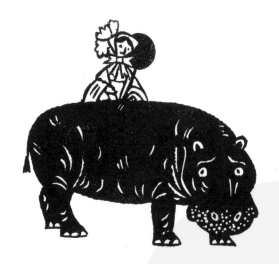

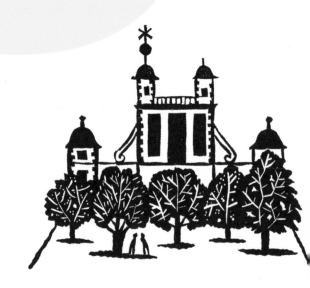

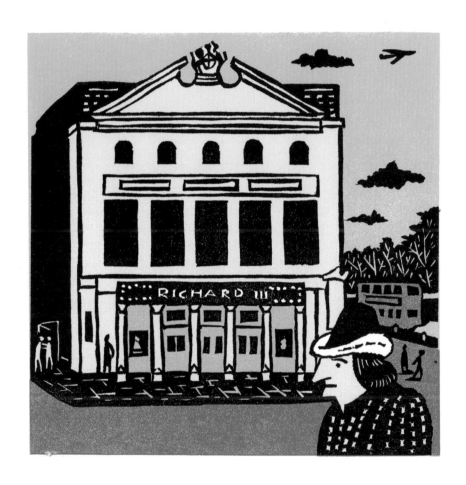

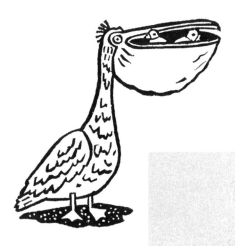

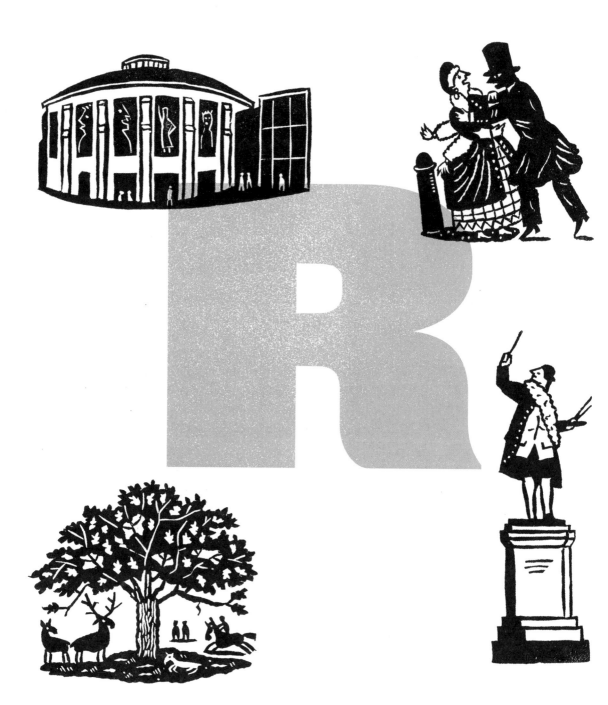

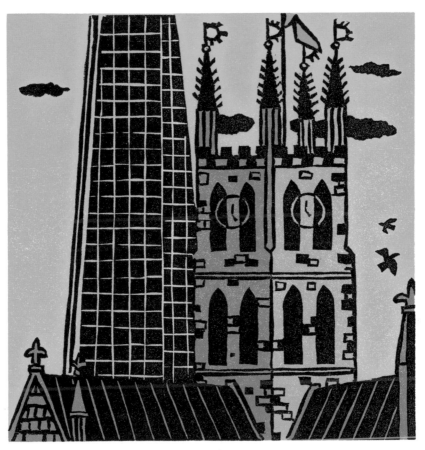

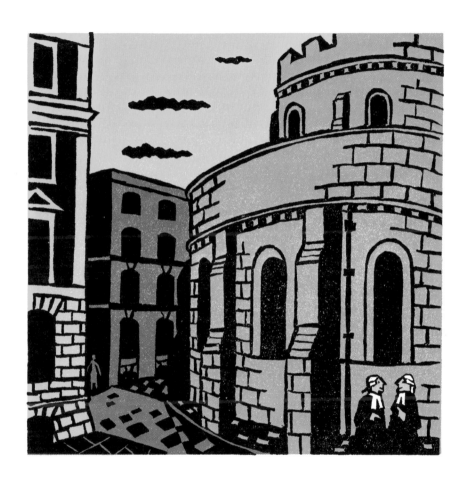

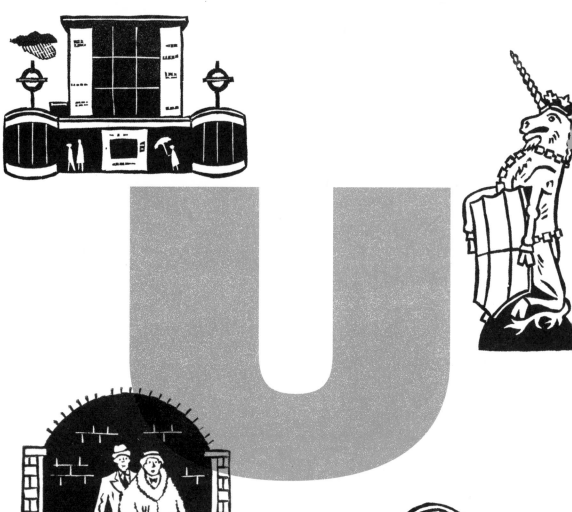

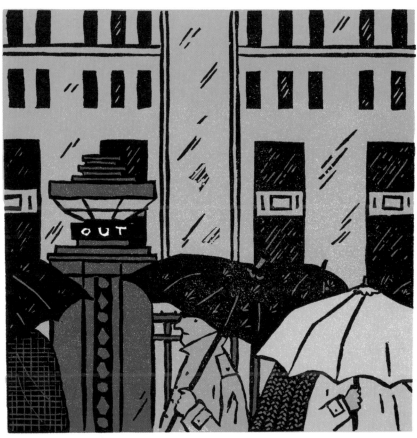

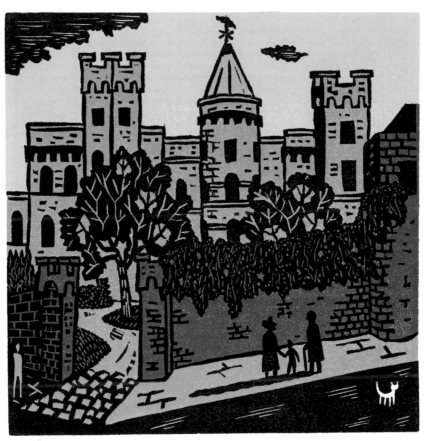

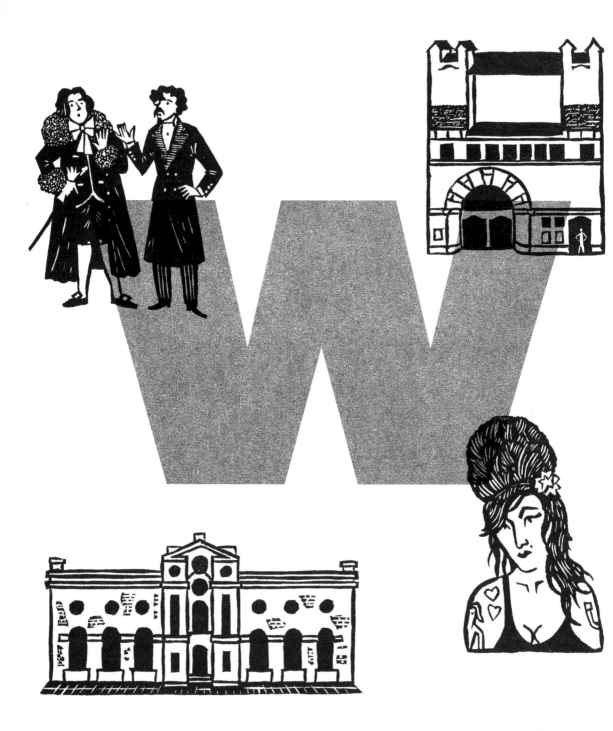

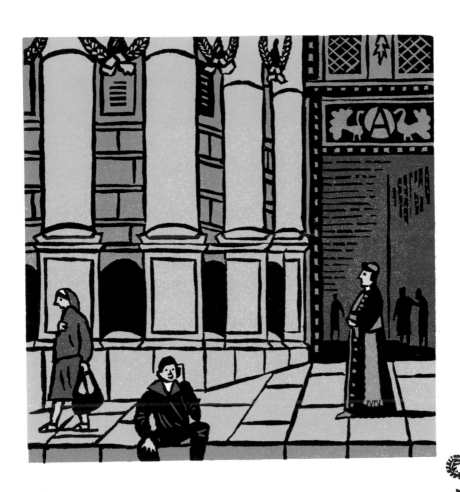

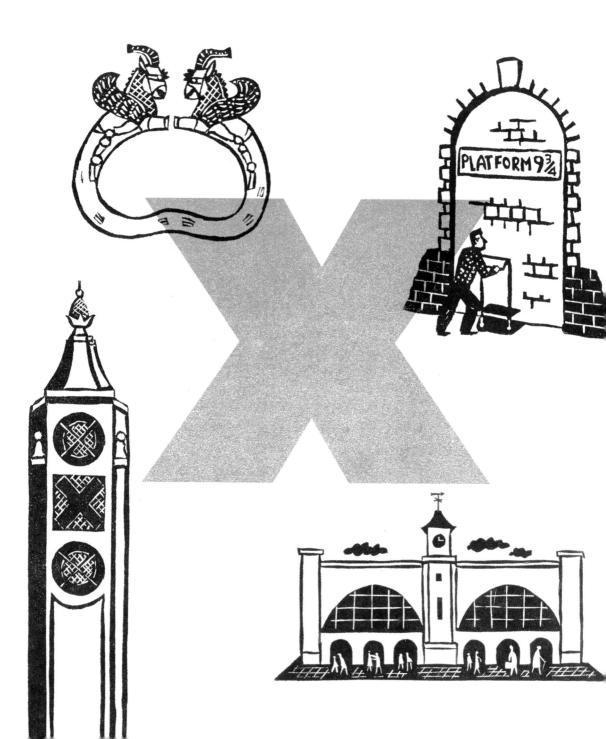

PLATFORM 9¾

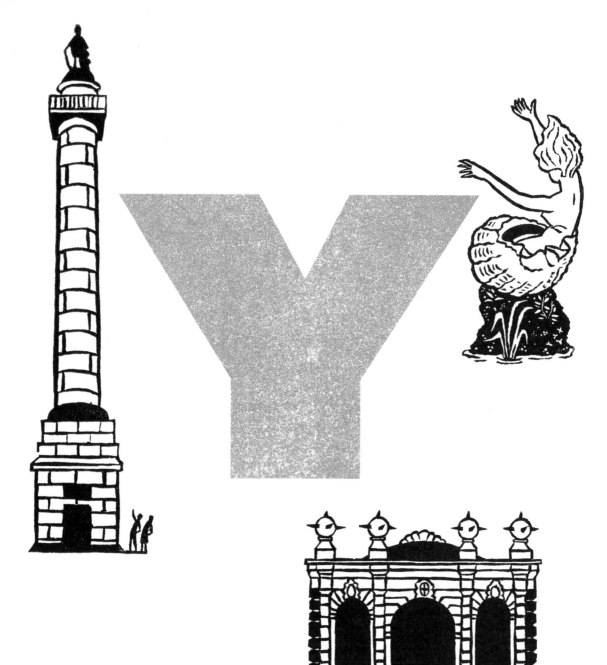

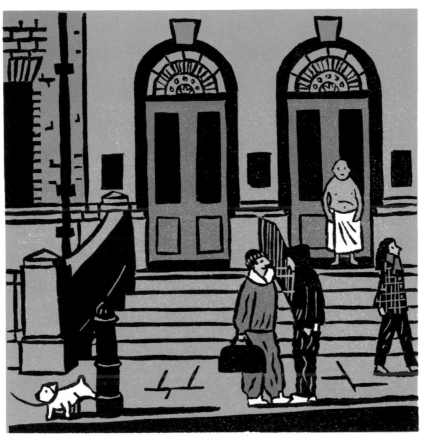

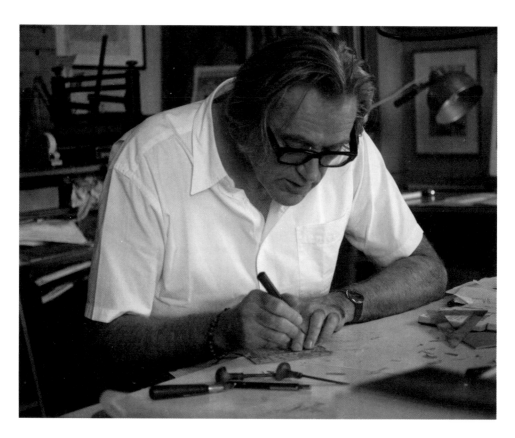

 MUSEUMS.
PERHAPS A LINE OF THEM

QUEUE.
CHARACTERS. (PERHAPS SOME OF
THE LITERARY ONES.).

VERY MUCH ABOUT THE THAMES
TOWER

WORKING IN LONDON

While I was at the Royal College of Art in London, my tutor arranged a meeting with Edward Bawden (1903–1989), who is considered by many to be the master of the linocut, and Edward suggested that I have a go at cutting a print. After leaving college I experimented with a variety of media, but the linocut has become my preferred working method. A friend once described linocutting as 'like potato printing'. In truth, it is; it's printing in its simplest form, easily done by a seven-year-old at school or at home on the kitchen table. The materials are relatively inexpensive, and although it helps to have a printing press, the back of a spoon or one's feet can be just as effective. There is something thoroughly enjoyable about the cutting and printing process, the smell of the lino and the ink, the anticipation as one gently pulls back the paper from the block to reveal an image that with luck bears some relationship to the original concept and design.

An Alphabet of London, as in the case of many of my projects, started with a response to text: in this instance, an

alphabetical list of places, people, events and a category I labelled 'other' (this included the weather, food, songs and objects from museums). The next task – daunting but enjoyable – was to edit the inventory, decide which would make suitable subjects for each letter and try not to add yet more to the list. The last task has proved difficult; on hearing about the project, many friends have suggested ideas that I had omitted or even failed to think of.

The next step was to visualize the list, to put pen to paper. Searching London by foot, bus, Tube and riverboat with a pocket-size Moleskine plain notebook and a camera, I started making quick sketches and taking photographs. I had to plan my journeys, mapping my routes after thorough research so that I could visit as many places as possible. One such route took me from the Temple along Fleet Street to St Paul's Cathedral, taking in many of the City churches and the Guildhall before ending at the London Stone. Although it was a Sunday, I entered some of the churches quietly (as I'd expected them to be all but empty), and to my surprise one had a full congregation of

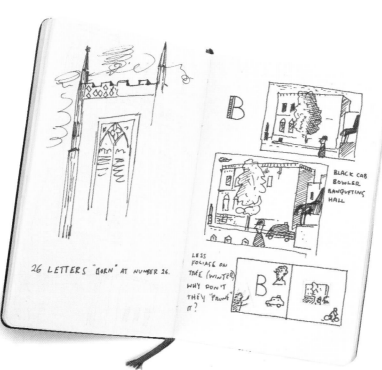

26 LETTERS "BORN" AT NUMBER 26.

BLACK CAB
BOWLER
BANQUETING
HALL

LESS
FOLIAGE ON
TREE (WINTER)
WHY DON'T
THEY "PRUNE"
IT?

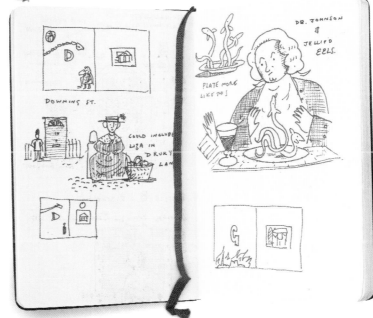

DOWNING ST.

COULD INCLUDE
LIZA IN
DRURY
LANE

DR. JOHNSON
&
JELLIED
EELS.

PLATE MORE
LIKE THIS

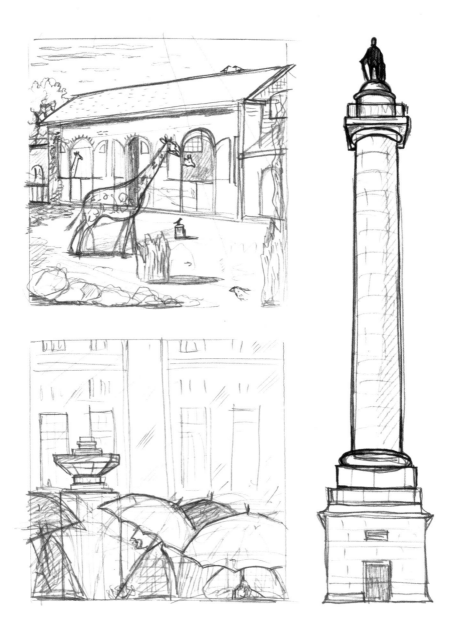

Chinese people and a service in Mandarin; another was filled with men in turbans and women in jewel-like saris.

On the frequent rainy days I spent time drawing in London's museums. The Victoria and Albert has been a favourite since my student days, when we could enter it through the Illustration Department of the RCA rather than walking down Exhibition Road. I've learned to be more at home at the British Museum, filled with its wonderful treasures that I always used to find overwhelming. However, the smaller collections have proved the most inspirational and pleasurable: the Museum of London, the Museum of London Docklands, the Hunterian Museum, the Wellcome Collection, Sir John Soane's Museum and the Petrie Museum are examples.

All the large and many of the smaller images in this book have been produced using my sketches, however cursory; I took photographs simply to help me with the details. Both are aides-memoires, helping me to establish a sense of place, and I use my imagination to add the suggested narrative. Back at my desk I translated the drawings from my sketchbook, working on layout paper to change the scale, drawing and redrawing until I had established a composition or design with which I was happy.

At this stage in the linocutting process the image is traced to be transferred on to the lino block. I turn the tracing paper

over, fold it carefully around the block and fasten it with masking tape so it doesn't shift as I burnish the paper with a pencil to transfer the image in reverse on to the block. Once the tracing paper is removed I make sure the lines are legible by going over them in pencil on the lino.

Cutting then begins. Using three basic tools – a Japanese knife, a fine V tool and a U tool – I carefully cut and gouge the design out of the lino. Usually I know which areas I wish to remain black, but the transferred drawing is not simply copied when being cut; the design process continues until the last piece of lino is flicked from the block. If I am in any doubt about the design I will print an early proof to see if the image works. It is always easy to cut away more if necessary, but tricky to put lino back. When working on a character, I'll always start with the eyes – too often I've left them till last, only for an eye to pop out!

Once cut, the block is proofed on photocopying paper. I use an oil-based relief printing ink, which gives a rich, solid black when dry. The ink is squeezed on to a thick sheet of glass, then spread evenly using a roller so that a thin layer adheres to the roller. Too much ink will fill any finer details; too little will result in an uneven print.

To print, I use a small tabletop press, which is perfect for the size of blocks I cut. Many years ago, when I assisted

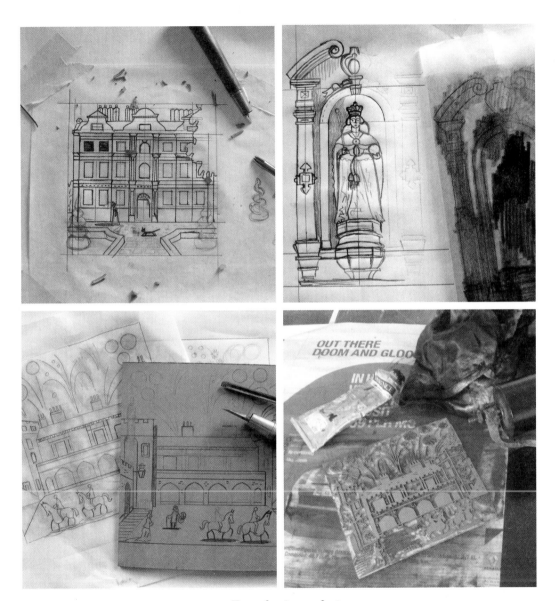

Transferring a design

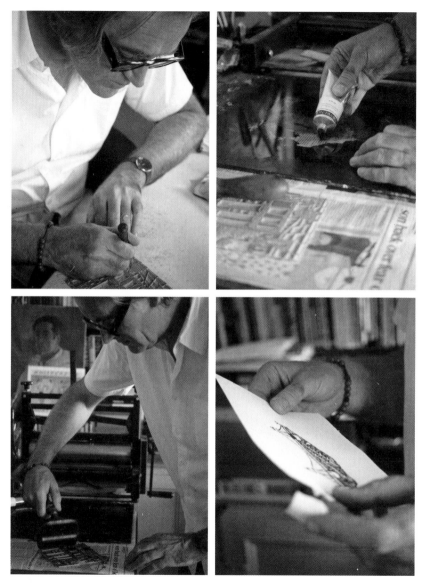

Cutting (top left), inking (top right and bottom left)
and the finished print (bottom right)

Edward Bawden with a large print of Saffron Walden Church, we used our feet, which was very effective. Additional cutting may be required before I pull a final proof on Zerkall paper. For colour prints, I photocopy a final black-and-white print and then use coloured markers to block in areas, giving me an indication

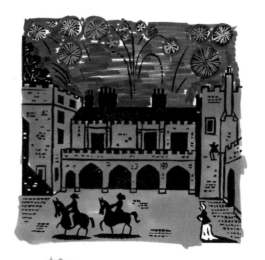

of colour and tonal balance. Once I am happy with the colour rough I refer to a Pantone book to choose the exact shades. This process is the same whether I am mixing colours with ink or using Photoshop on a computer. The computer is used simply to help me visualize my ideas.

Starting a project is always difficult, and so is its ending. I didn't start this project with A and finish with Z; it was actually B and X. My selection – personal, eclectic, surprising – is intended to include both the famous and the lesser-known aspects of London that delight me; I hope it will encourage you to discover your own alphabet as you look at the city afresh.

INDEX

G

Globe Theatre, Bankside
gin drinker
Gherkin, 30 St Mary Axe, City of London (Foster + Partners, 2004)
Great Fire of London (1666)
Great Plague (1665–66)
Gilbert and George and the art of the East End

H

Henry VIII and Hampton Court Palace
highwayman
Hoover Building, Perivale (Wallis, Gilbert and Partners, 1938)
Highlander, Museum of London (early nineteenth-century tobacconist's sign)
The Head of the River Race, Hammersmith Bridge
Hodge, the oyster-eating cat of Samuel Johnson

I

St Sarkis Armenian Church, Iverna Gardens, Kensington (Charles Mewès and Arthur Davis, 1923)
Indian ice-skating
Henry Irving (actor, 1838–1905)

ivory hand-clapper, Petrie Museum of Egyptian Archaeology
The Queen's Tower, Imperial College London (Thomas Edward Collcutt, 1893)
Imperial Russian uniform, Imperial War Museum (First World War)

J

St James's Palace and Jubilee fireworks
Jewish community
Stephen Jones (milliner) in his shop in Great Queen Street, Covent Garden
Queen Elizabeth II's Diamond Jubilee (2012)
Jumbo (African elephant, 1861–1885)
Samuel Johnson (writer, 1709–1784) eating jellied eels

K

Kew Palace (1631)
The Knight King, Henry V
Kensington Palace (Christopher Wren, 1694)
John Keats (poet, 1795–1821) and the Keats house, Hampstead
Ronnie and Reggie Kray (gangsters, 1933–1995 and 1933–2000)
Kensal Green Cemetery (1833)

L

Little Venice
Lord Mayor of London
Little Tich (Harry Relph, 1867–1928) and Marie Lloyd (1870–1922), music-hall stars
Little Ben (Victoria station, 1892)
Gothic House, Langford Place, Paddington, formerly the home of Charles Saatchi

M

East London Mosque, Whitechapel, and Muslim community
Christopher Marlowe (writer, 1564–1593)
Marble Arch and marathon runners
grave of Karl Marx (1818–1883), Highgate Cemetery, and a magpie
Michelin House, Fulham Road, Chelsea (François Espinasse, 1911)
Alexander McQueen (fashion designer, 1969–2010)

N

National Gallery (William Wilkins, 1838) and Nelson's Column (William Railton, 1842), Trafalgar Square
Norman warrior

Noah's Ark, Museum of Childhood, Bethnal Green (*c.* 1830)

Naked Bike Ride and Notting Hill Carnival

statue of Isaac Newton, British Library (Eduardo Paolozzi, 1995), and newspapers

narwhal, Natural History Museum

O

Old Vic Theatre, Southwark, and Laurence Olivier (1907–1989) as Richard III

Oliver Twist

Royal Observatory, Greenwich (Christopher Wren, 1675)

Olympic Games

Obaysch (hippopotamus, ?1849–1878)

Joe Orton (playwright, 1933–1967)

P

Pagoda, Royal Botanic Gardens, Kew (William Chambers, 1762), and a picnicking Pearly King and Queen

Mary Poppins

Charles Pooter (George and Weedon Grossmith, *The Diary of a Nobody*, 1892)

police box, Hercule Poirot and Paddington Bear

pelican eating pigeons

Peckham Rye and the angels, as seen by William Blake

Q

The Queen's House, Greenwich (Inigo Jones, 1635)

Mary Quant (fashion designer, born 1934)

The Six Queens of Henry VIII (left to right): Catherine of Aragon (divorced); Anne Boleyn (beheaded); Jane Seymour (died); Anne of Cleves (divorced); Catherine Howard (beheaded); Katherine Seymour (survived)

The Queen's Chapel, St James's Palace (Inigo Jones, 1625)

The Marquis of Queensberry with a bouquet of rotten vegetables for Oscar Wilde at the premier of *The Importance of Being Earnest* (14 February 1895)

R

Royal Naval College, Greenwich (Christopher Wren, 1694)

rugby

Royal Academy of Arts and Joshua Reynolds (artist, 1723–1792)

red deer and riding in Richmond Park

Roundhouse, Camden (former engine shed, 1847; redeveloped in 2006 by John McAslan + Partners)

Jack the Ripper

S

Shard (London Bridge Tower, Renzo Piano Building Workshop, 2012) and Southwark Cathedral

Sarah Siddons (actress, 1755–1831)

scold's bridle, Wellcome Collection (Belgian, sixteenth century)

spires of (left to right) St Margaret Pattens (1687), St Benet Paul's Wharf (1683) and St Margaret Lothbury (1690), all by Christopher Wren

Savile Row suit

Selfridges Clock, 'The Queen of Time' (Gillett & Johnston, 1931)

T

Temple Church, City of London

tourist

Tippoo's Tiger, Victoria and Albert Museum (*c.* 1793)

Trinity Buoy Wharf Lighthouse, Poplar (1866), the only lighthouse on the River Thames

trepanned skull, Wellcome Collection (Jericho, 2200–2000 BC)

Tate Modern, Bankside (Giles Gilbert Scott, 1952/1963; Herzog & de Meuron, 2000)

U

University of London (Senate House, Charles Holden, 1937); umbrellas

usherette

Underground (Earl's Court station, Harry Ford, 1915)

'Underneath the Arches' (song popularized by Flanagan and Allen, 1931)

Underground (Eastcote station, Charles Holden, 1939)

unicorn, Hampton Court Palace

Vanbrugh Castle, Maze Hill (John Vanbrugh, after 1718)

Viking warrior

London to Brighton Veteran Car Run, first raced in 1896, and Queen Victoria

house by Charles Voysey, Bedford Park, Chiswick

Queen Victoria's dolls 'Sir William Arnold' and 'Gertrude, Lady Arnold', Museum of London (*c.* 1832)

Westminster Cathedral (John Francis Bentley, 1903)

Dick Whittington

Amy Winehouse (singer-songwriter, 1983–2011)

Woolwich Arsenal, Old Officers' Mess (1695)

the wit of Oscar Wilde (writer, 1854–1900) and James Abbott McNeill Whistler (artist, 1834–1903)

Whitechapel Gallery (Charles Harrison Townsend, 1901)

King's Cross station (Lewis Cubitt, 1852) (also opposite, bottom right)

boxer (Daniel Mendoza, 1764–1836, the inventor of 'modern' boxing)

OXO Tower, South Bank (Albert Moore, 1929)

The Oxus Treasure, British Museum (Persian, fifth and fourth centuries BC)

Platform 9¾, King's Cross station, as described by J.K. Rowling in the Harry Potter novels

York Hall, Bethnal Green

Yeoman of the Guard

York House water gate, Embankment Gardens

Duke of York's Column, Waterloo Place (Benjamin Dean Wyatt and Richard Westmacott, 1834)

statue of a sea nymph in York House Gardens, Twickenham

Giraffe House, London Zoo (Decimus Burton, 1837)

zoo-keeper and zebra

tomb of Flight Sub Lieutenant Alexander Warneford (1891–1915), Brompton Cemetery, awarded the Victoria Cross for an attack on a zeppelin

defaced statues at Zimbabwe House (Jacob Epstein, 1908)

mechanical zebra toy, Museum of Childhood, Bethnal Green (Chinese, 1975–79)

statue of Wang Zhiming (Christian pastor, 1907–1973; Neil Simmons, 1998) over the west door of Westminster Abbey

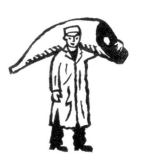

Dedicated to my mother, who
has always been there to hold my hand.

And

In memory of my father
Sidney John Walter Brown
1910–1976

and grandfather
Sidney Edwin Bertram Brown 1875–1964

ACKNOWLEDGEMENTS
My grateful thanks to Peter and Sian Bailey,
Chris Bird, Priscilla Carluccio, Jasper Conran,
Sebastian Conran, Jamie Harris, David Ivie,
Graham Miller and Tim Potter.

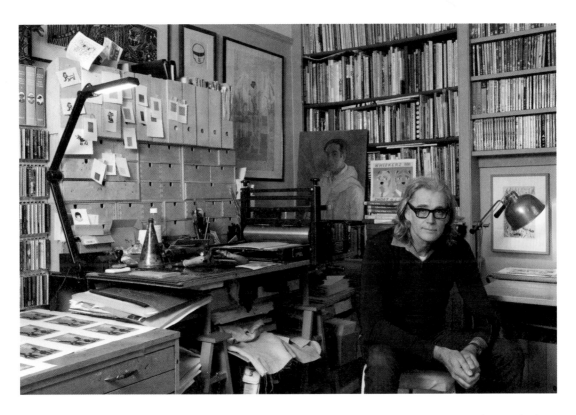

CHRISTOPHER BROWN has lived in London all his life. He studied at the Royal College of Art, where he met and later assisted the master of the linocut, Edward Bawden. He is an illustrator and print-maker, senior lecturer in Graphic Arts at Liverpool School of Art and Design, and a visiting lecturer in Fashion Menswear at Central Saint Martins and in MA Illustration at Camberwell College of Arts. His clients include the Folio Society, *The Guardian*, the *Sunday Times*, the *New Yorker*, the Bay Tree Food Company and Few and Far. His work has been exhibited widely in the United Kingdom, including at the Royal Academy of Arts, the Fry Gallery, the Victoria and Albert Museum and St Jude's Gallery, and he illustrated *A Pack of Dogs: An Anthology* (Merrell, 2010). misterchristopherbrown.com

JASPER CONRAN is an authority on British style and one of the United Kingdom's leading fashion designers, with a successful career spanning more than thirty years. He has applied his signature irreverent but classically British elegance to clothing, fragrance, eyewear, interiors and homewares. In 2008 he was appointed OBE for services to the retail industry.

First published 2012 by
Merrell Publishers Limited
81 Southwark Street
London SE1 0HX

merrellpublishers.com

British Library Cataloguing-in-
Publication data:
Brown, Christopher.
An alphabet of London.
1. London (England)–In art.
2. Brown, Christopher–Homes and
haunts–England–London–Pictorial
works.
3. Linoleum block-printing, English.
I. Title
769.4′9306′09421-dc23

ISBN 978-1-8589-4573-6

ISBN 978-1-8589-4573-6

9 781858 945736

Produced by Merrell Publishers
Limited
Designed by Nicola Bailey
Project-managed by Rosanna Lewis
Printed and bound in China

Jacket, front, clockwise from top
left: Little Ben (see L); Buckingham
Palace (1702; remodelled by
John Nash, 1826); Yeoman of the
Guard (see Y); 10 Downing Street
(see D); Samuel Johnson (see J);
St Paul's Cathedral (Christopher
Wren, 1710)
Jacket, back, clockwise from top
left: Horse Guard; Tower Bridge
(Horace Jones and John Wolfe
Barry, 1894); Mary Poppins (see
P); Westminster Abbey (1269);
Veteran Car Run (see V); Gherkin
(see G); the duel of George
Canning and Lord Castlereagh
(Cabinet ministers) on Putney
Heath, 1809 (centre)
Page 1, from left: Alfred Hitchcock
(film director, 1899–1980);
Edmond Halley (astronomer,
1656–1742); Sherlock Holmes
Page 2, from left: Emmeline
Pankhurst (suffragette leader,
1858–1928); child with gas mask,
Imperial War Museum; Charlie
Chaplin (actor and director,
1889–1977); the London Stone;
Quentin Crisp (writer and actor,
1908–1999); Florence Nightingale
(nursing reformer, 1820–1910)
Page 3: figure of 'Nobody', Victoria
and Albert Museum (c. 1680–85)
Page 4: Royal Albert Hall (Francis
Fowke and Henry Darracott Scott,
1871)

Page 5, clockwise from top left: John
Milton (poet, 1608–1674); Vivienne
Westwood (fashion designer, born
1941); Joseph Bazalgette (civil
engineer and designer of the
Albert, Victoria and Chelsea
embankments, 1819–1891);
Grayson Perry (artist, born 1960)
Page 6: Roman mask, Sir John
Soane's Museum (c. AD 117–138)
Page 7: Bust of Sir John Soane, Sir
John Soane's Museum (Francis
Chantrey, 1829)
Page 26: Thames barge and Tower
of London
Page 27: Cockney sparrow
Page 93: Meat porter, Smithfield
market
Page 94: Statue of pupil at Grey Coat
Hospital; walking stick in the
form of a monk's head, Museum
of London (fourteenth century)
Below: Parachuting pigeon, Second
World War
Endpapers: London dragon, from
the city's seventeenth-century coat
of arms

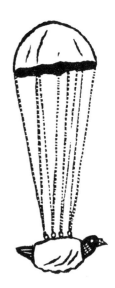